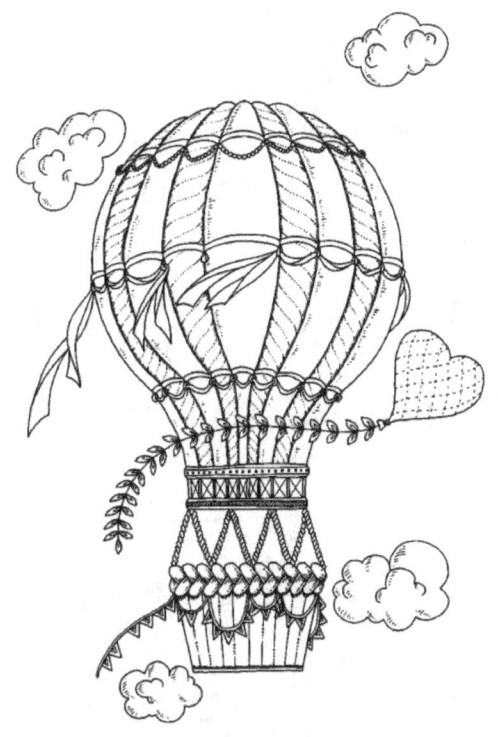

BALLOON PUBLISHING

Copyright 2017 Balloon Publishing

No part of this book may be reproduced or trasmitted in any form or by any means except for your own personal use or for a book review, without the written permission from the author

COLOR TEST PAGE

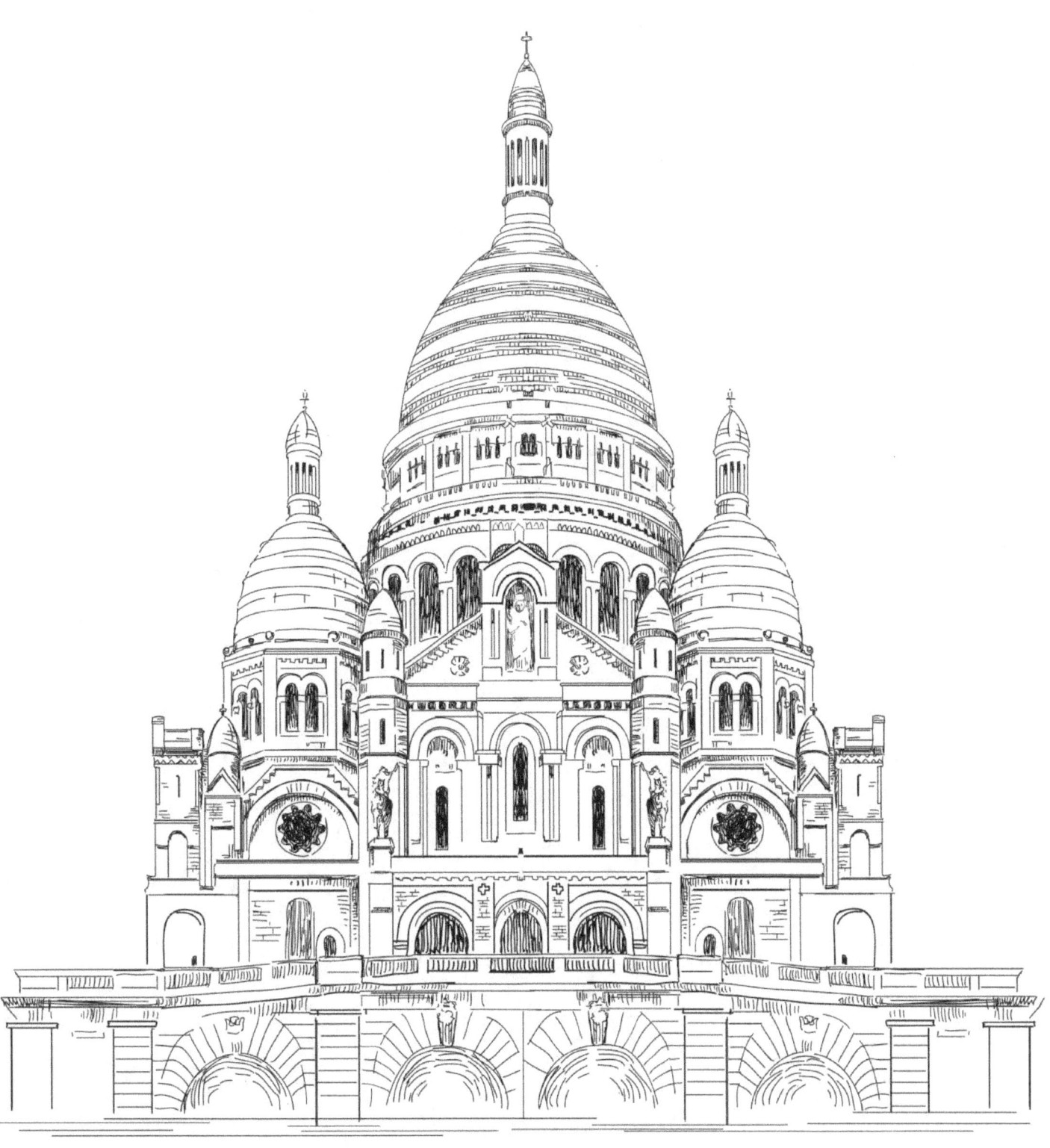

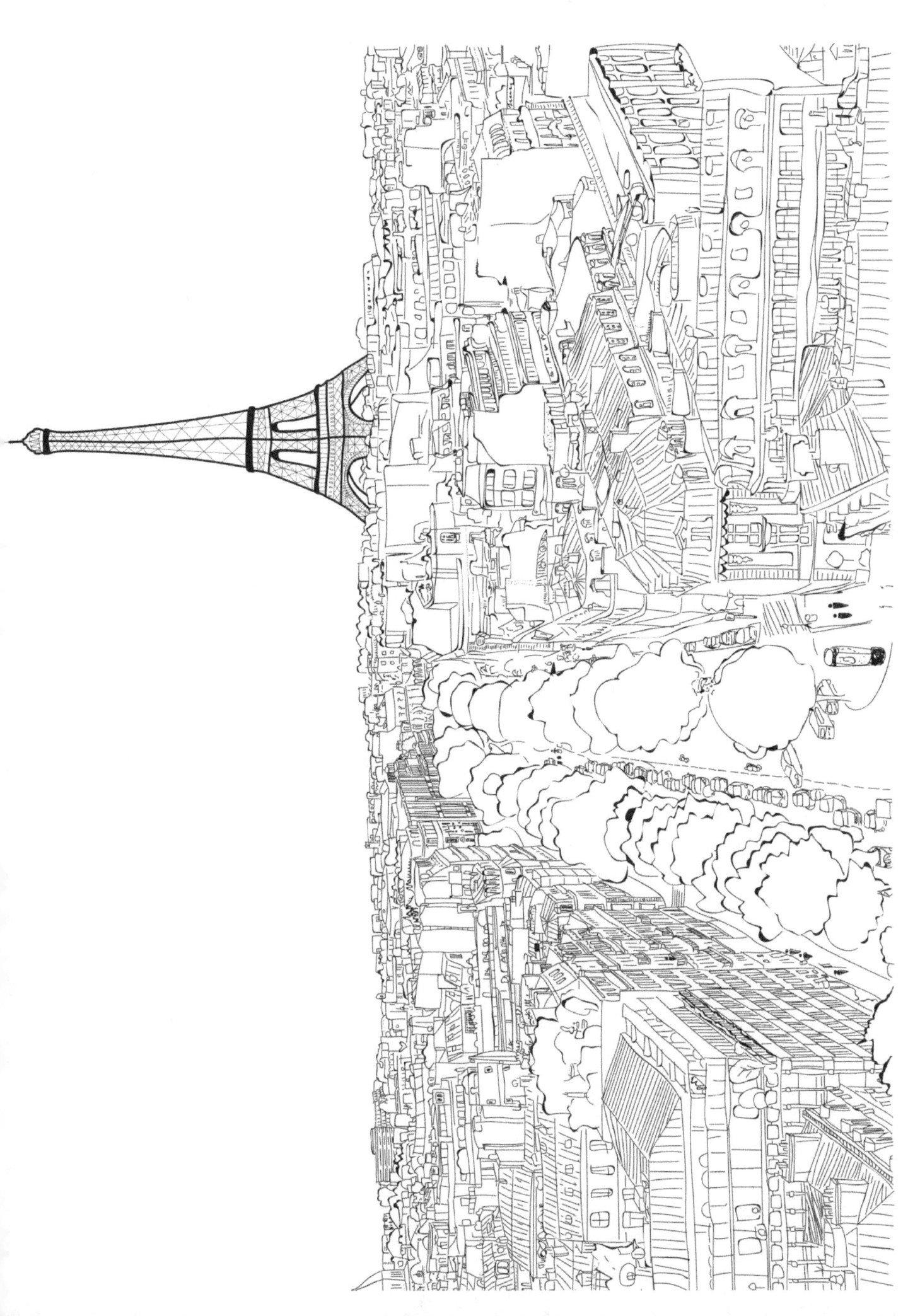

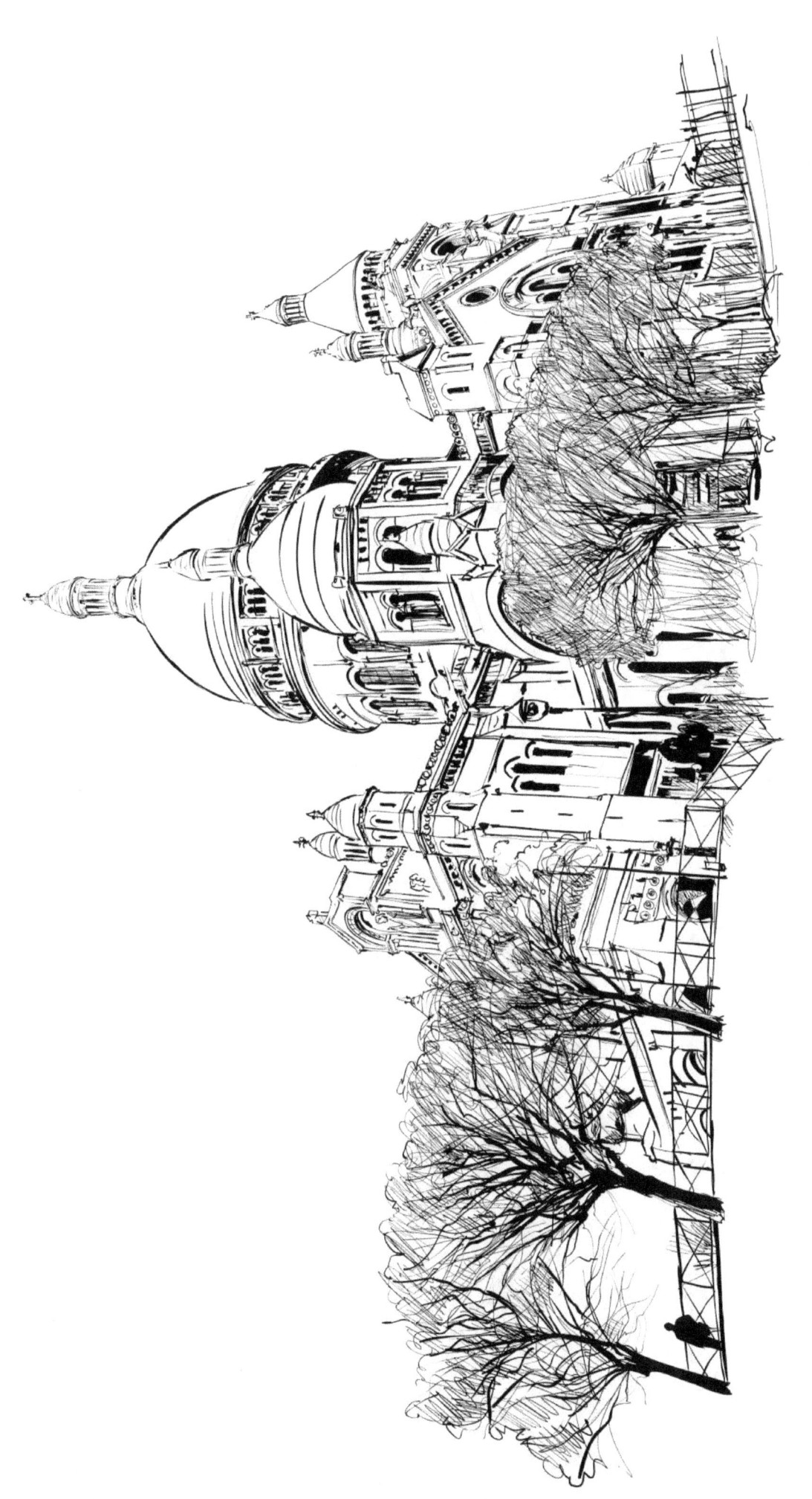

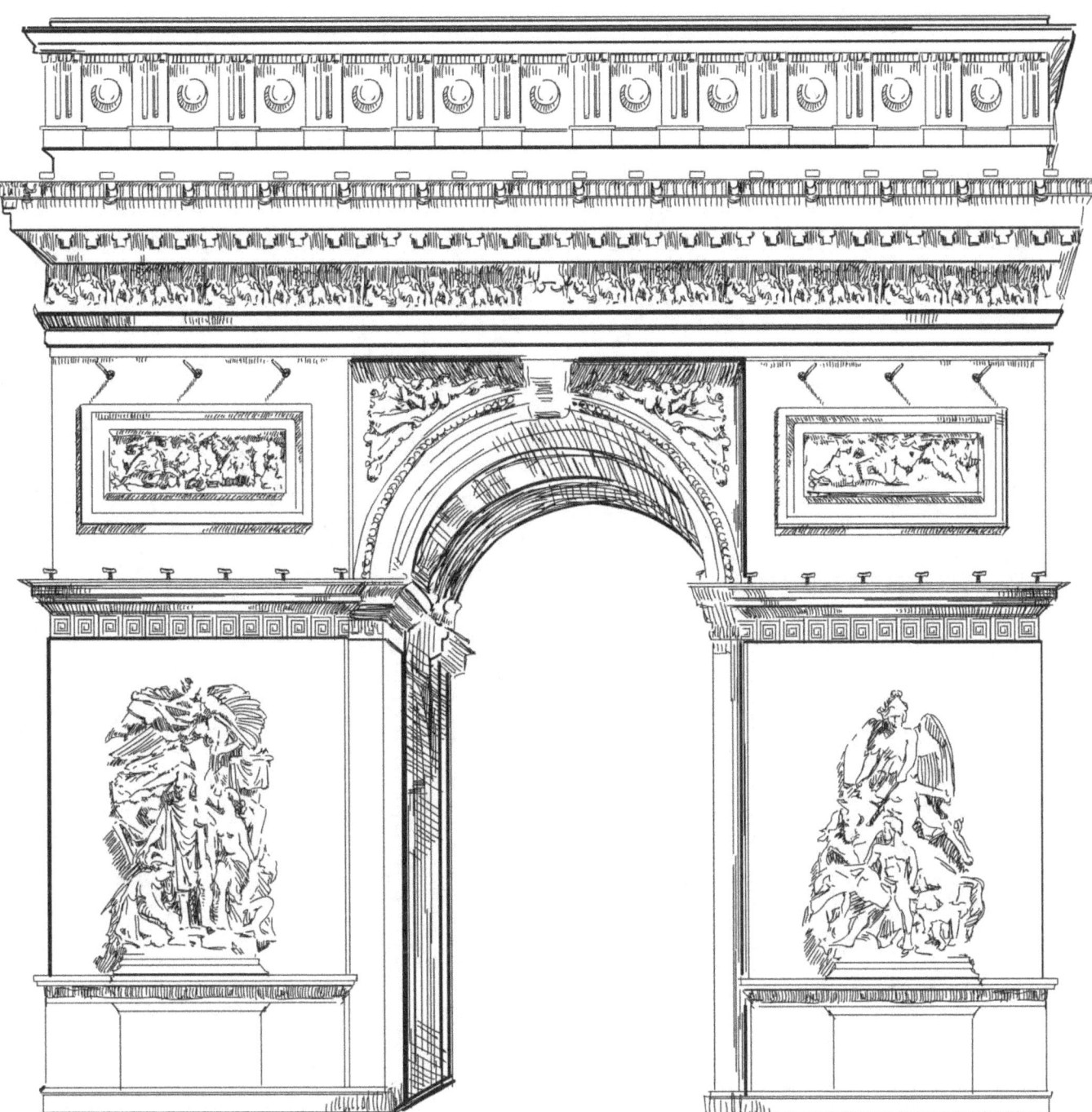

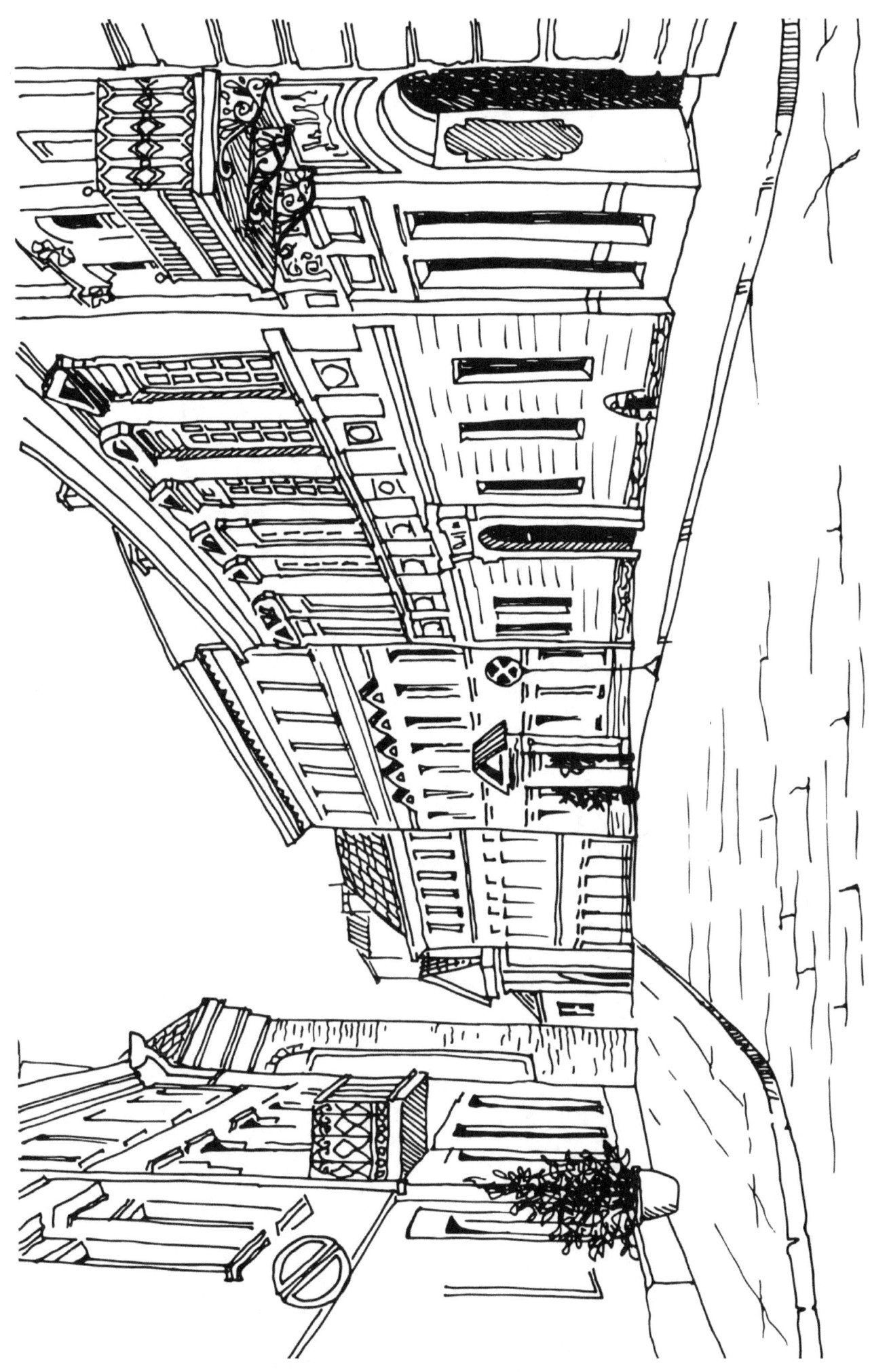

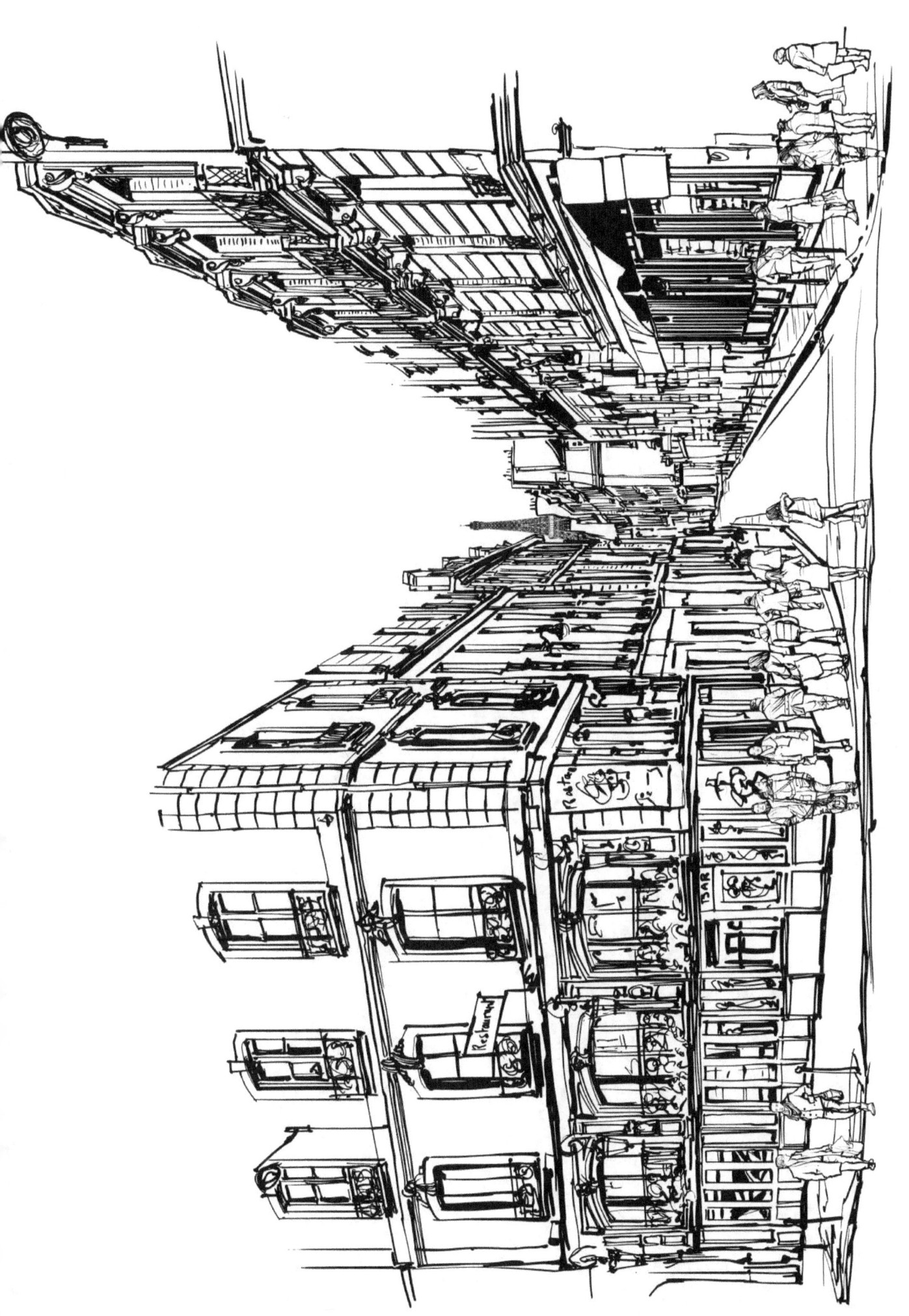

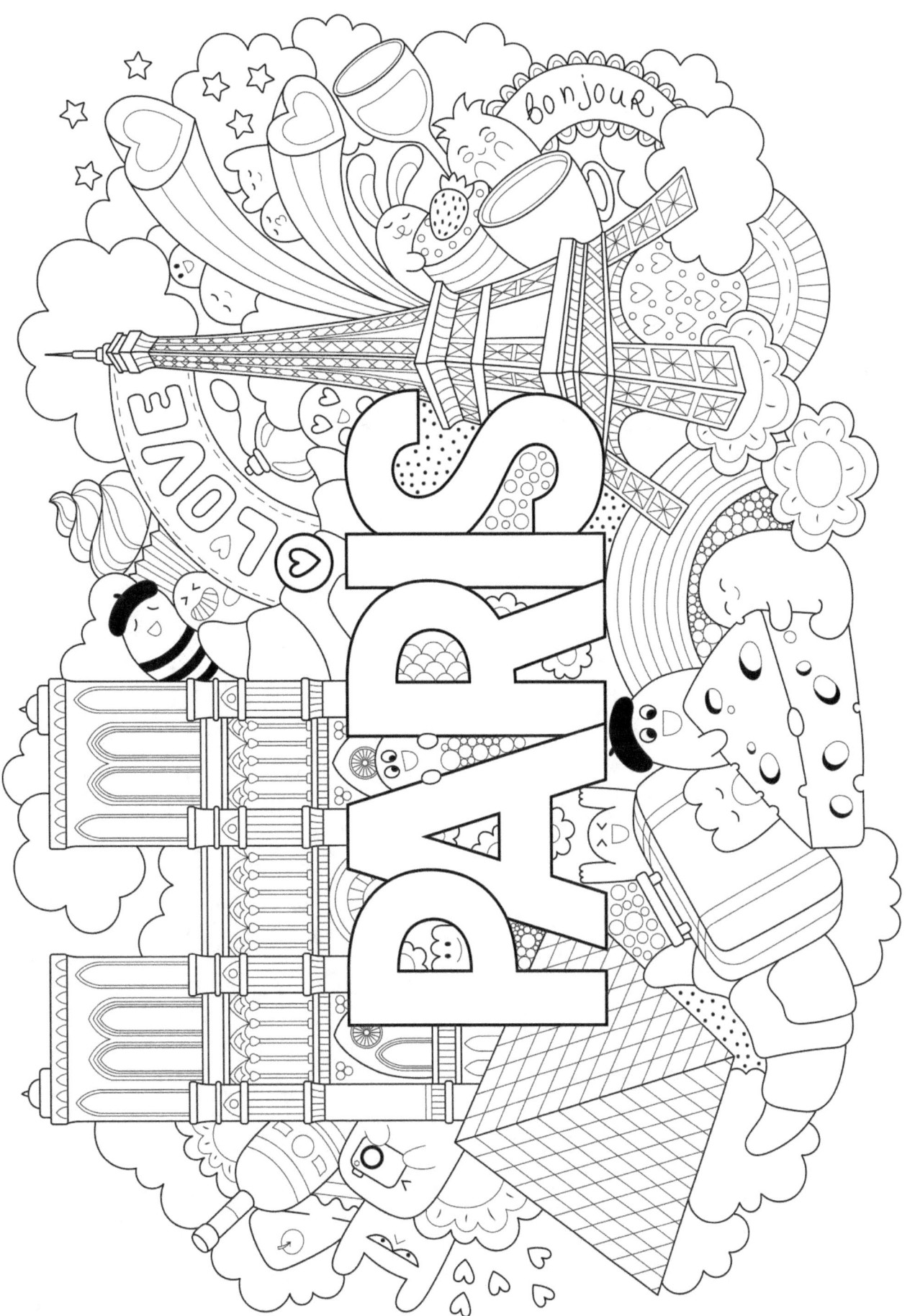

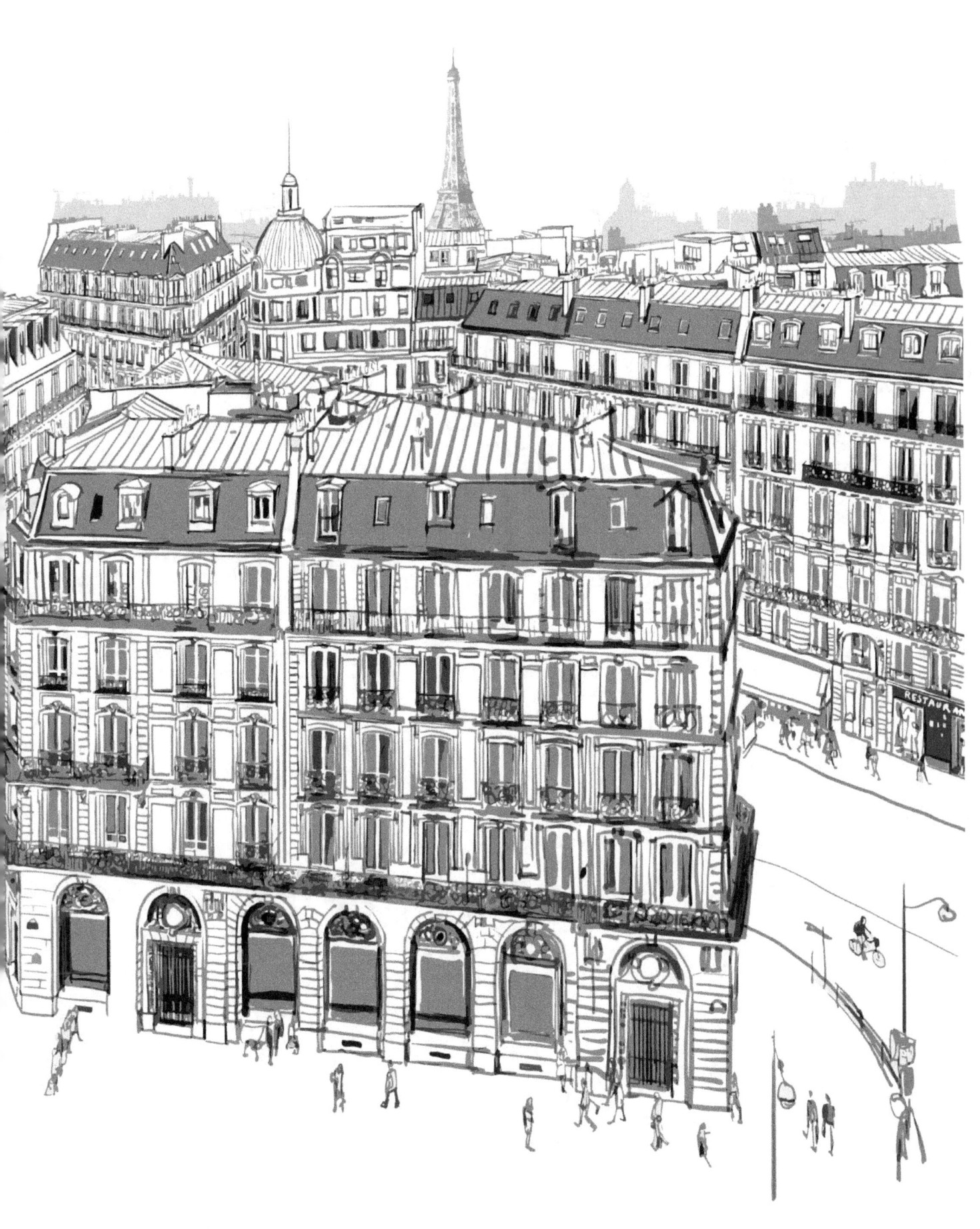

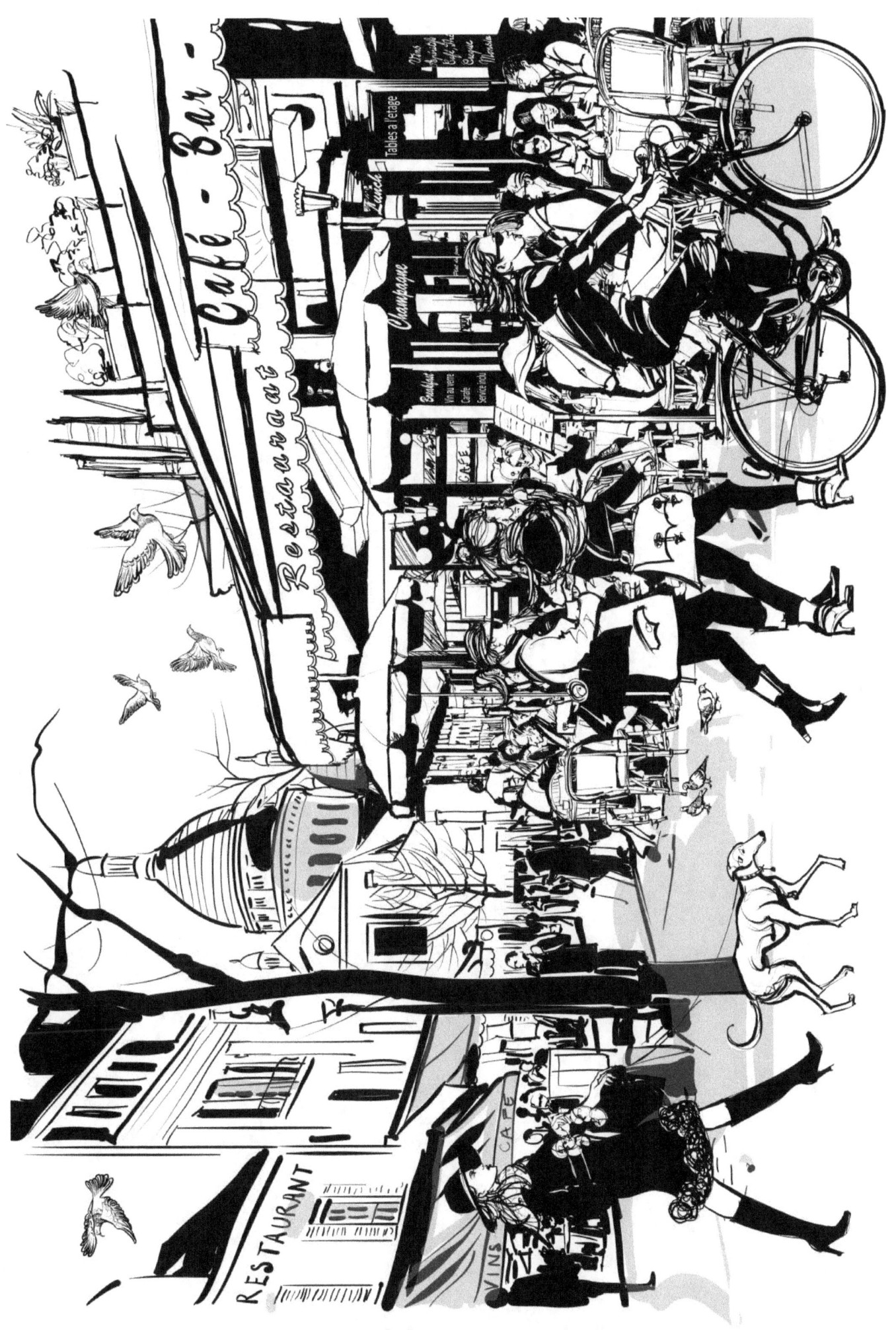

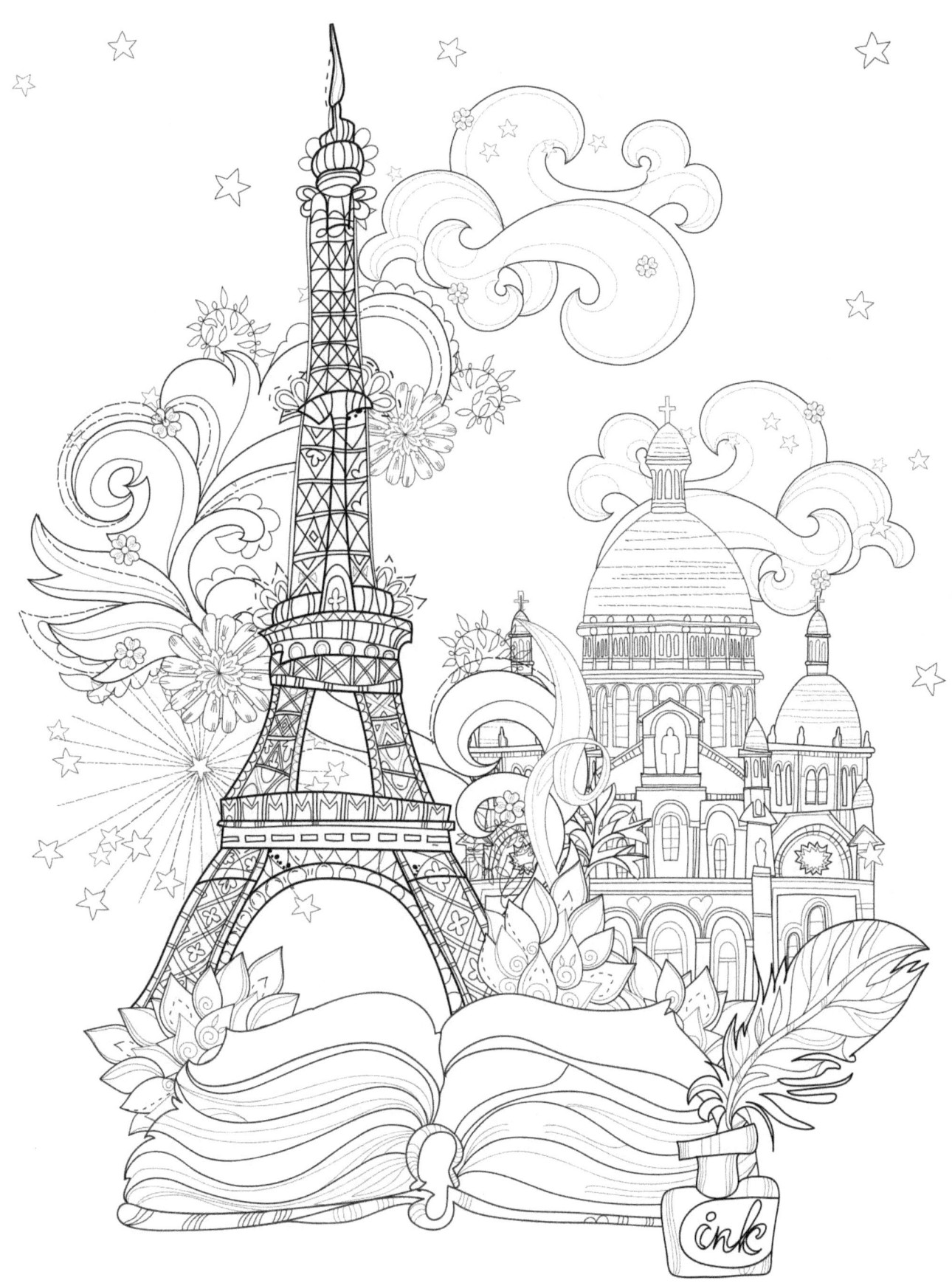

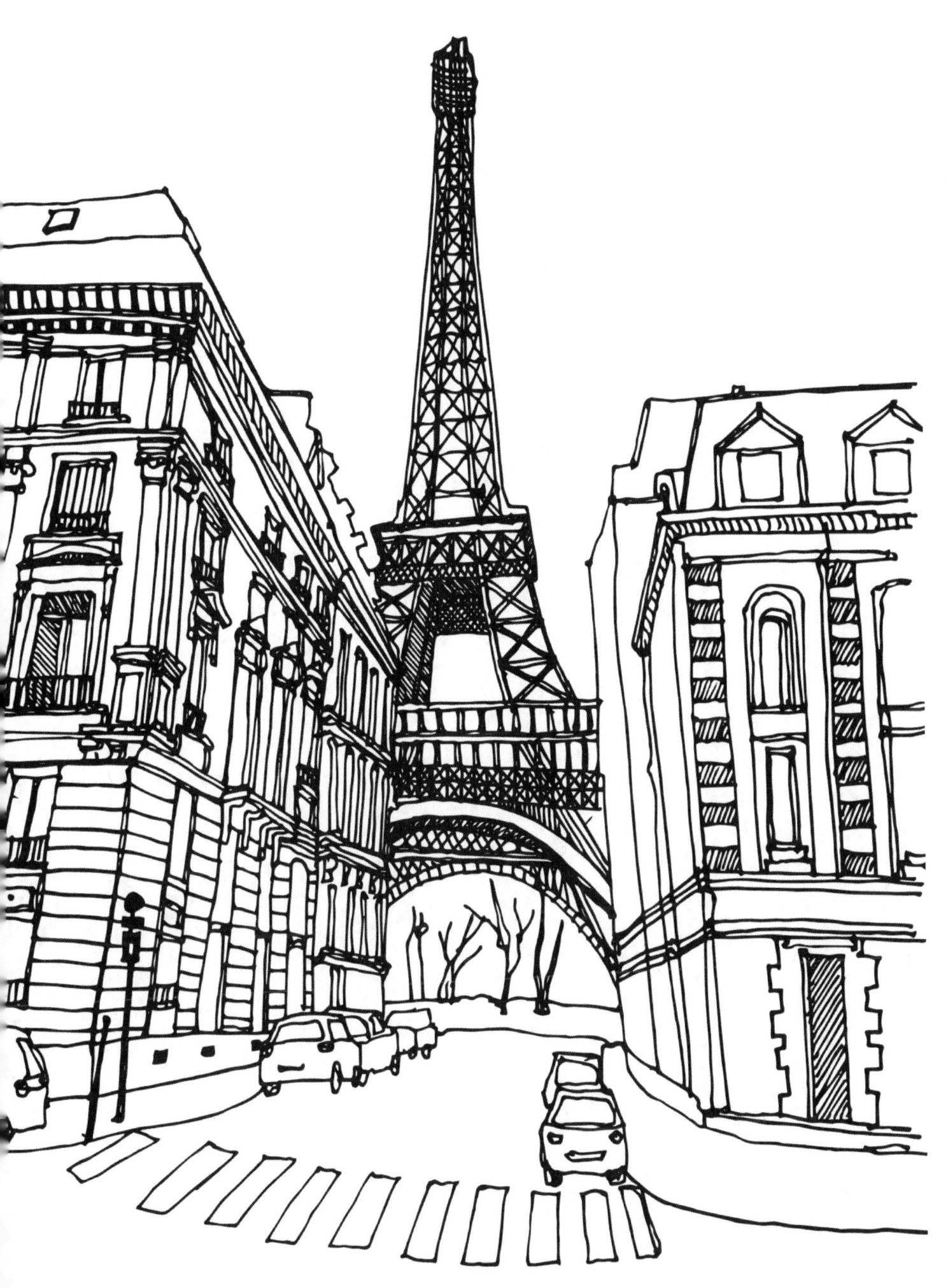

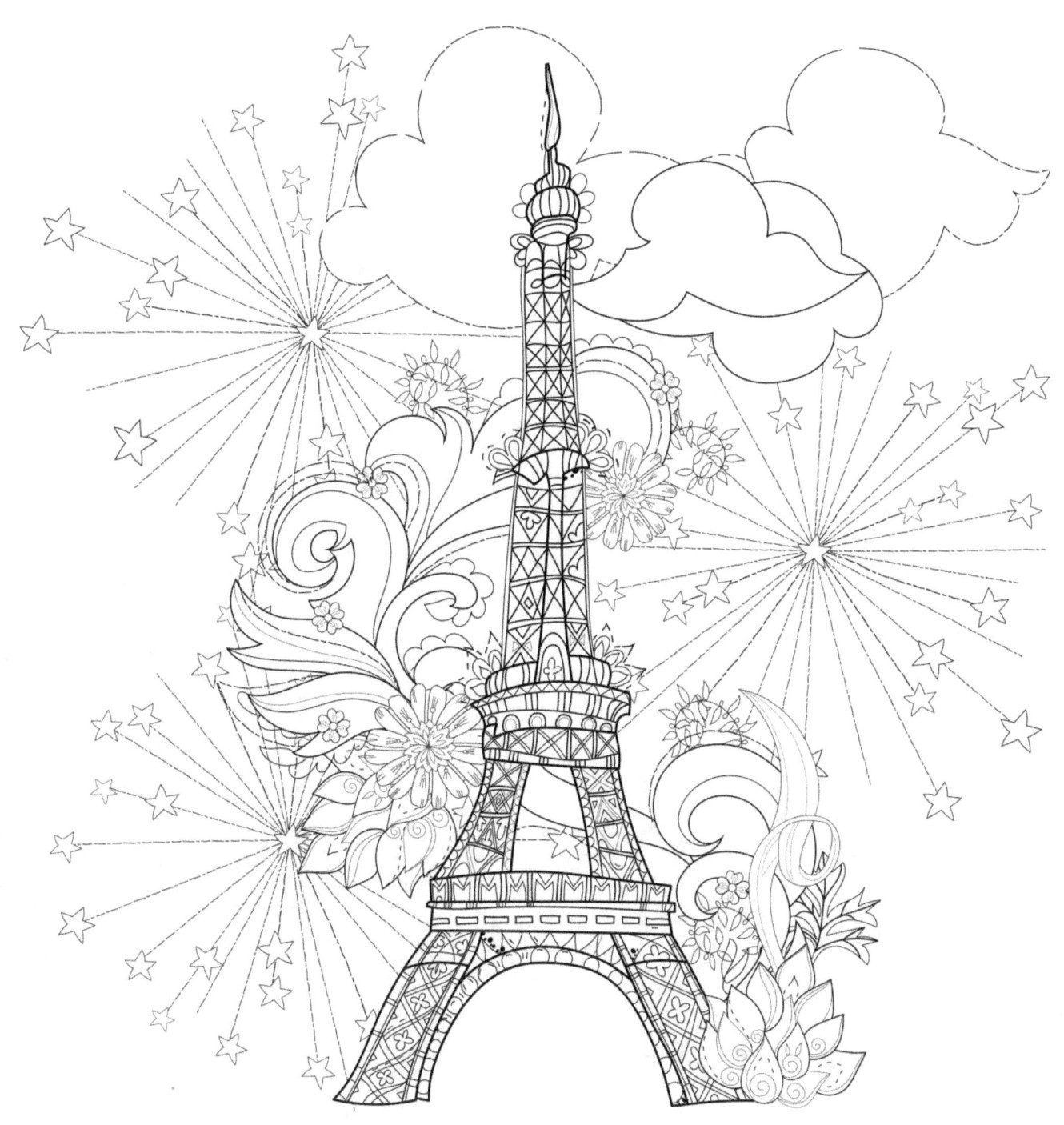

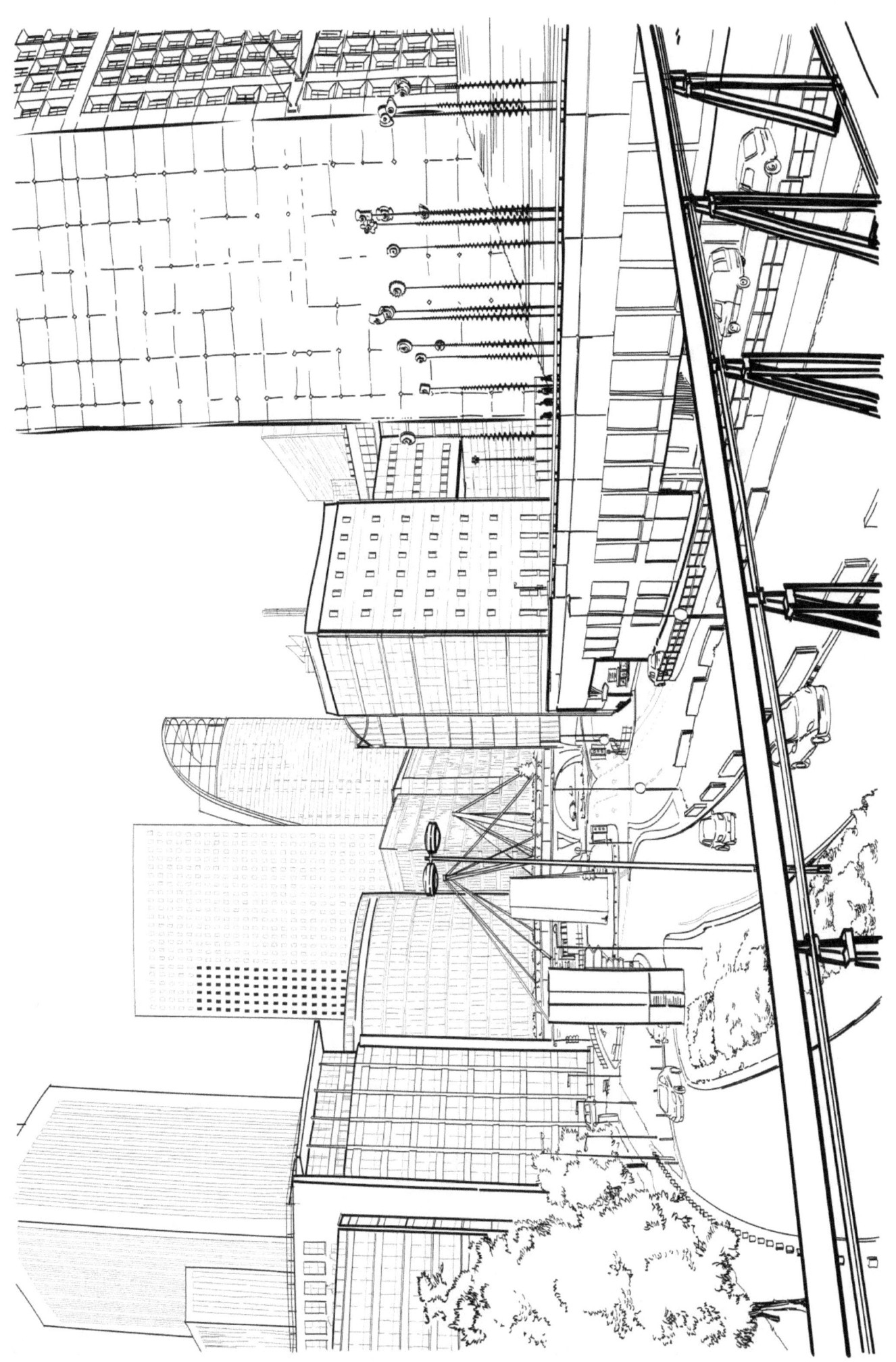

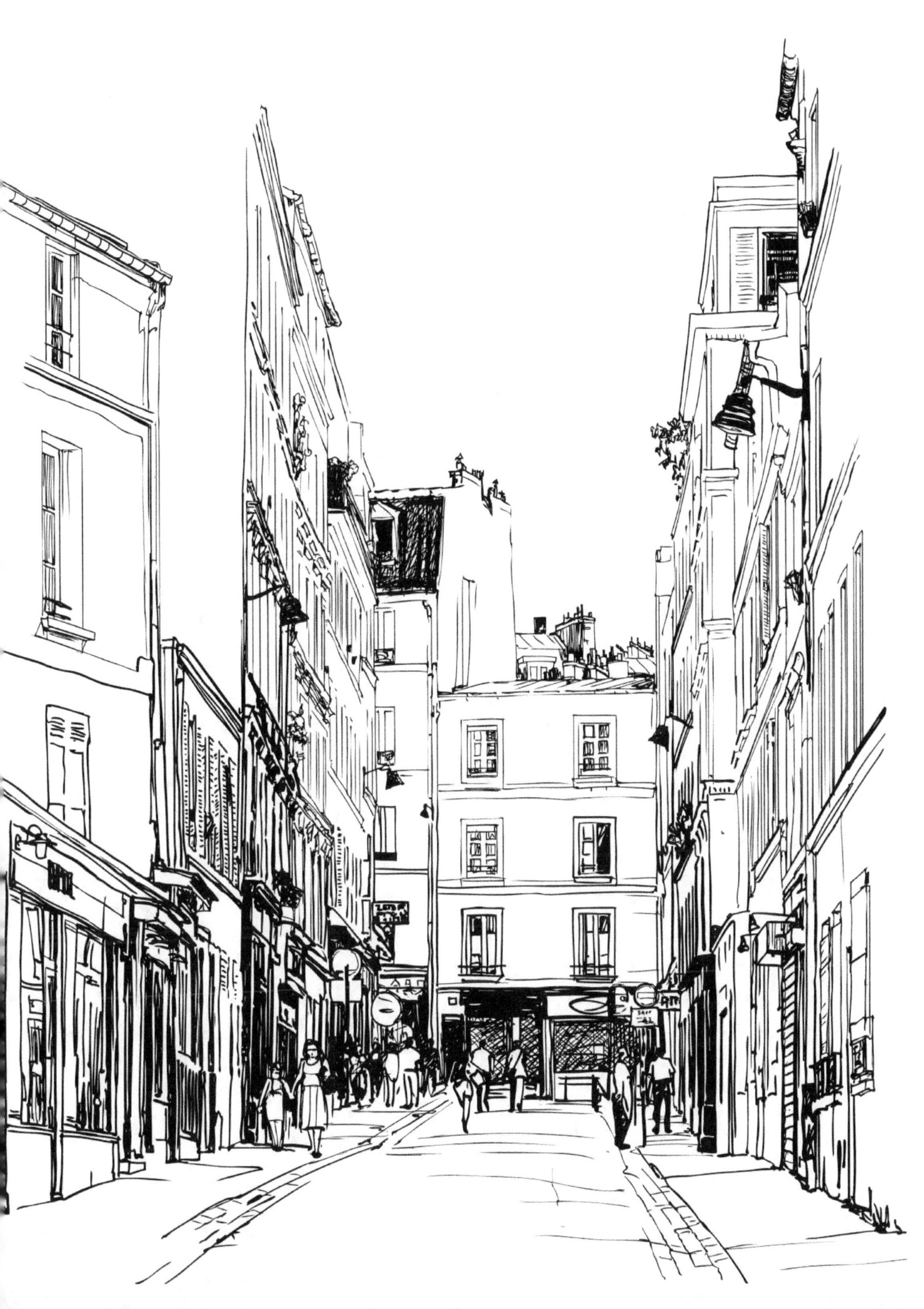

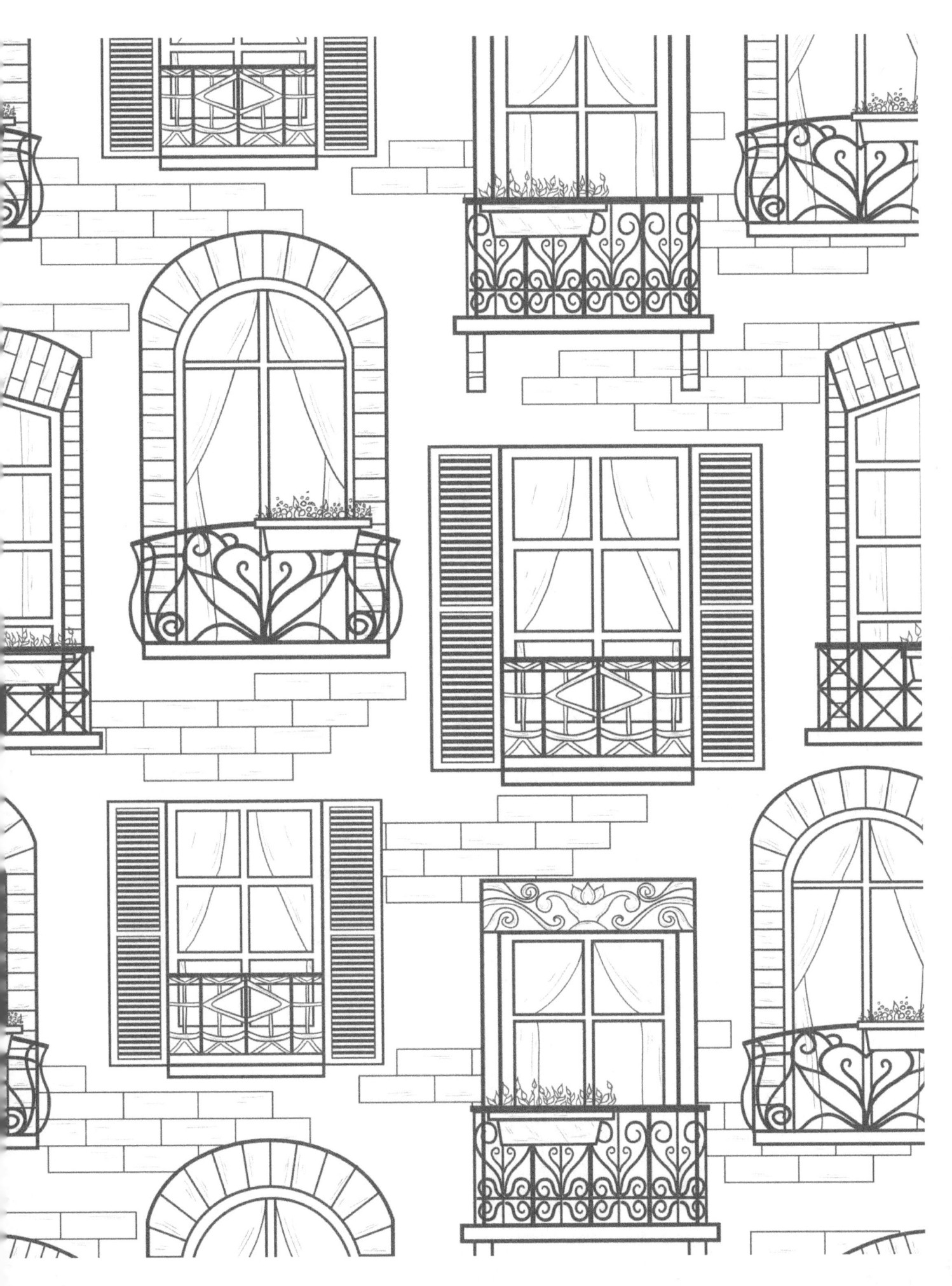

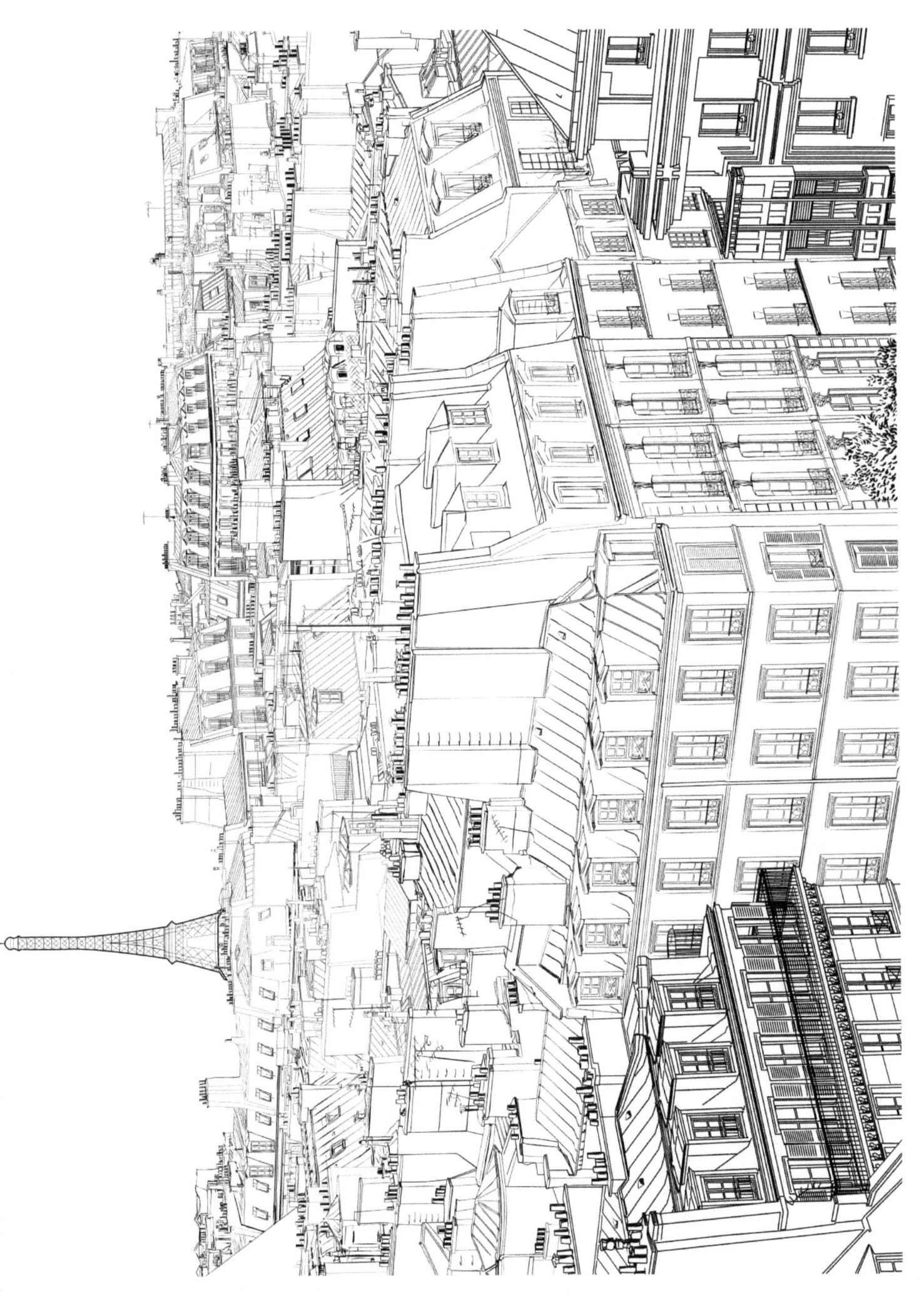

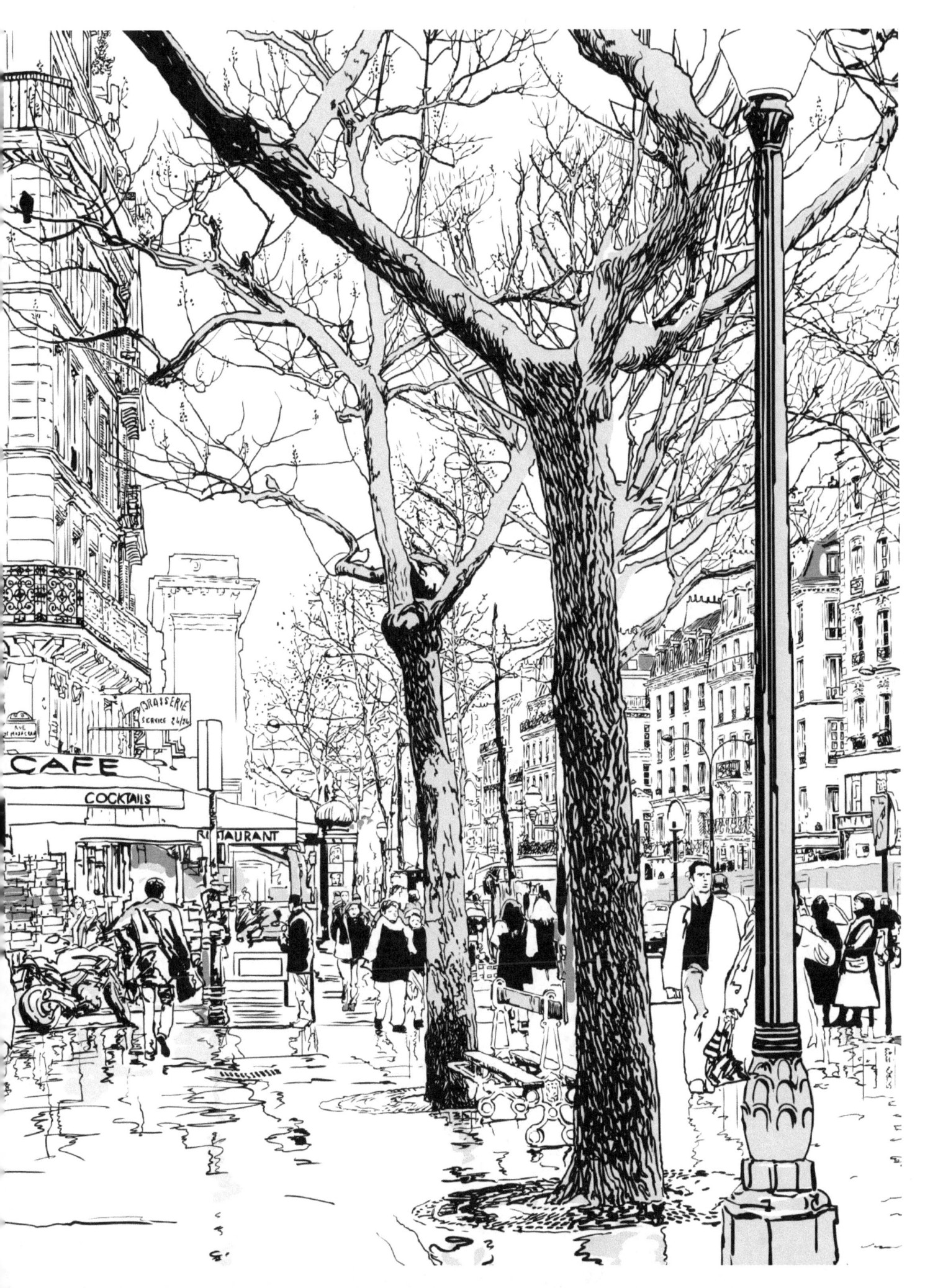

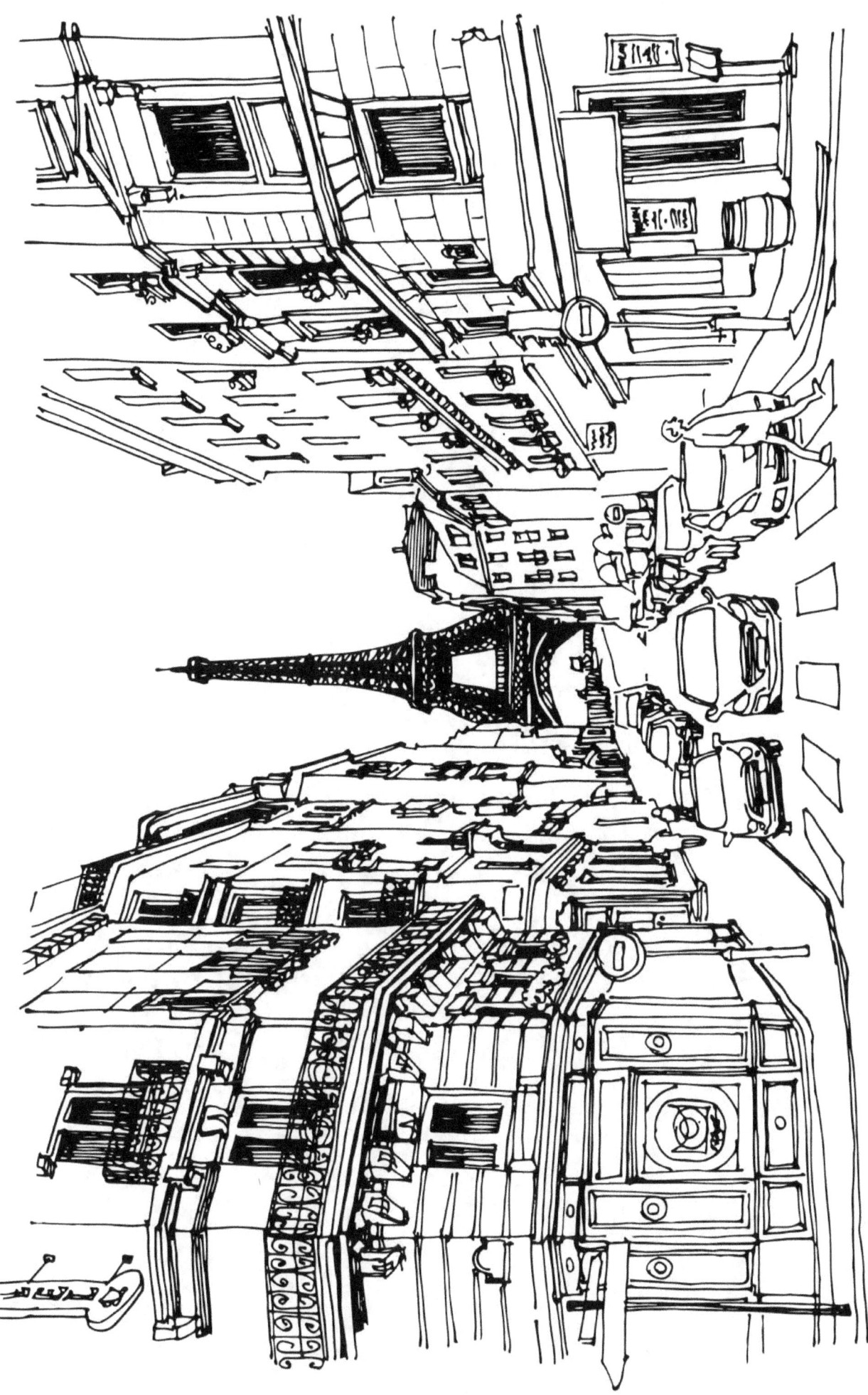

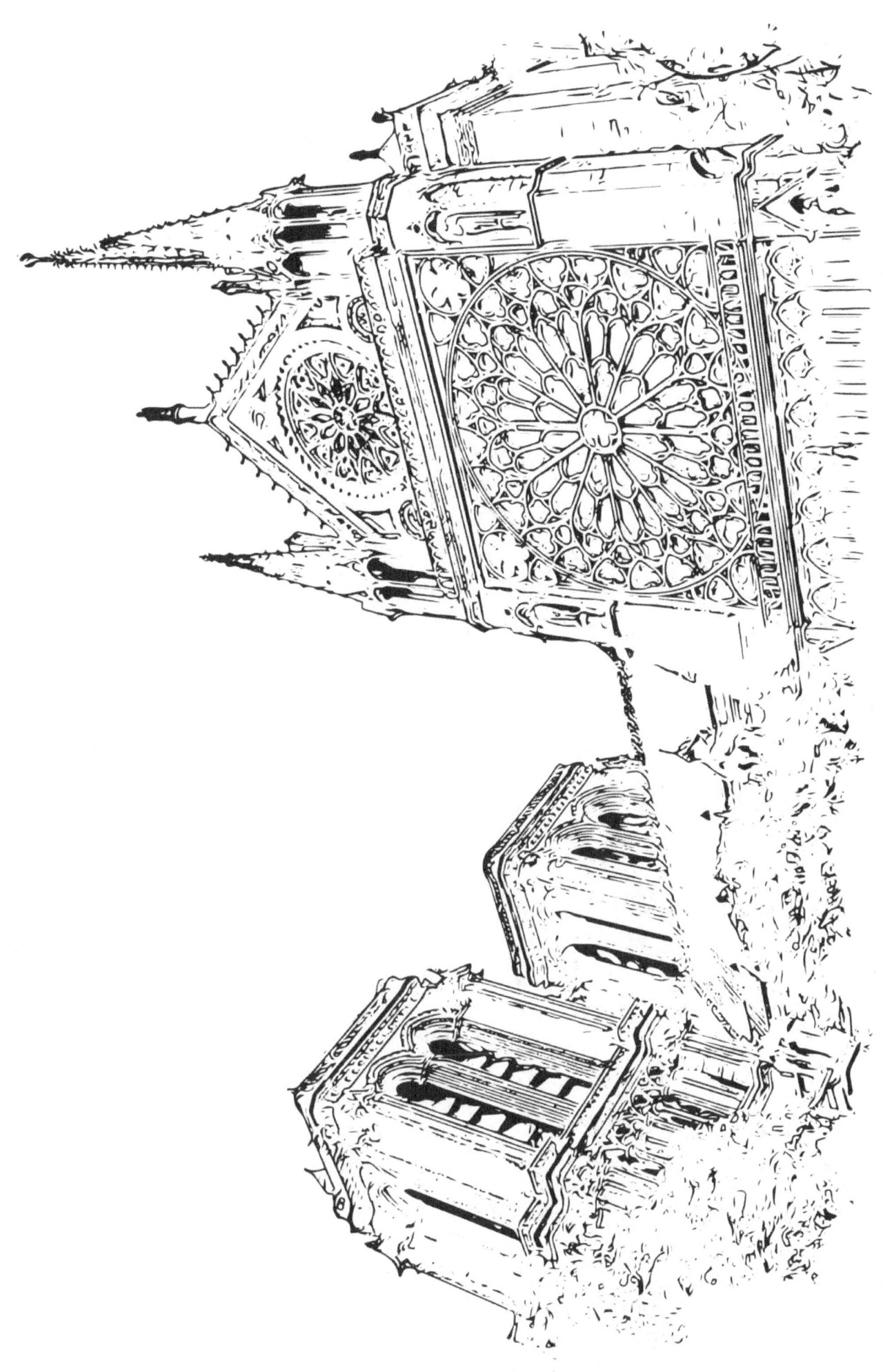

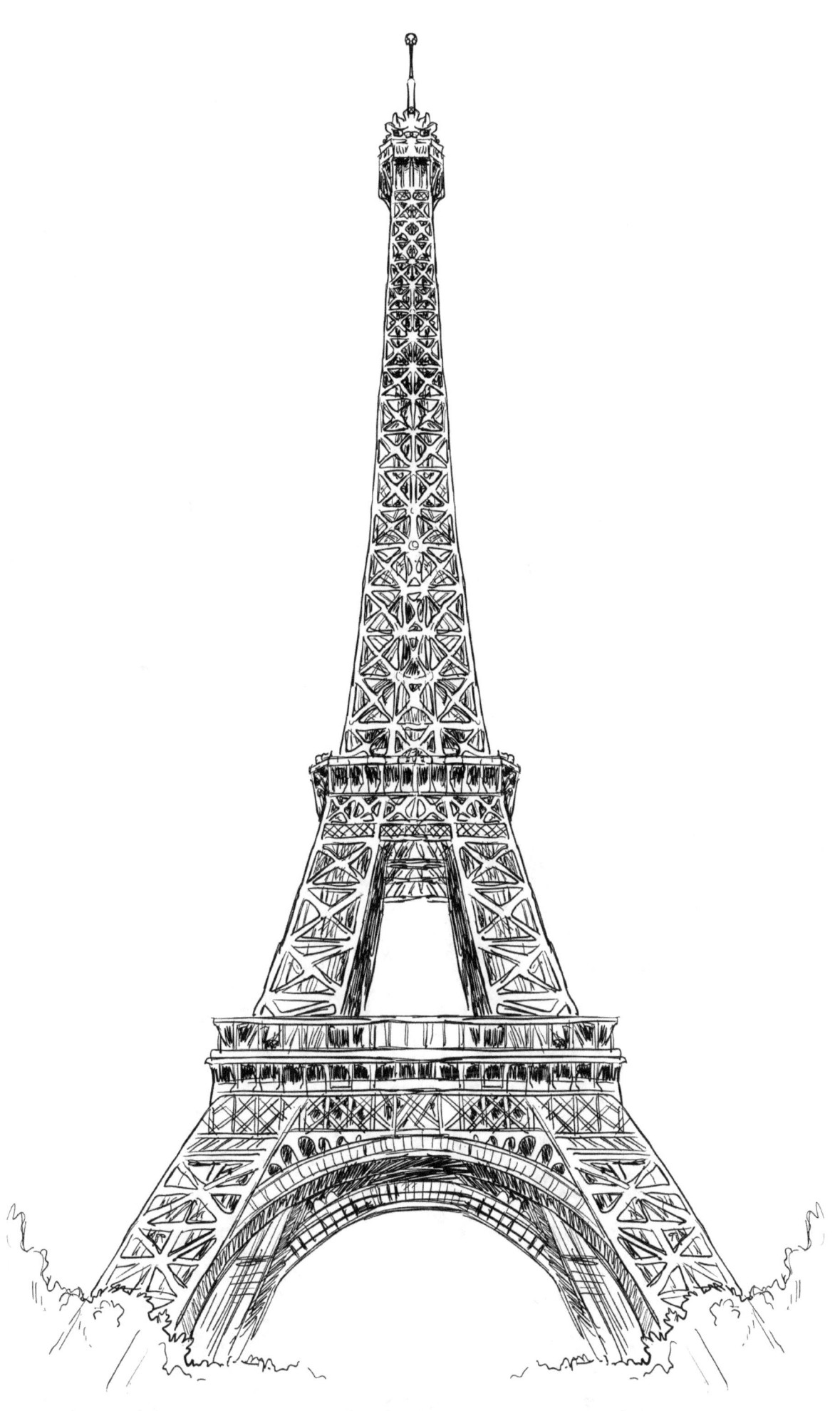

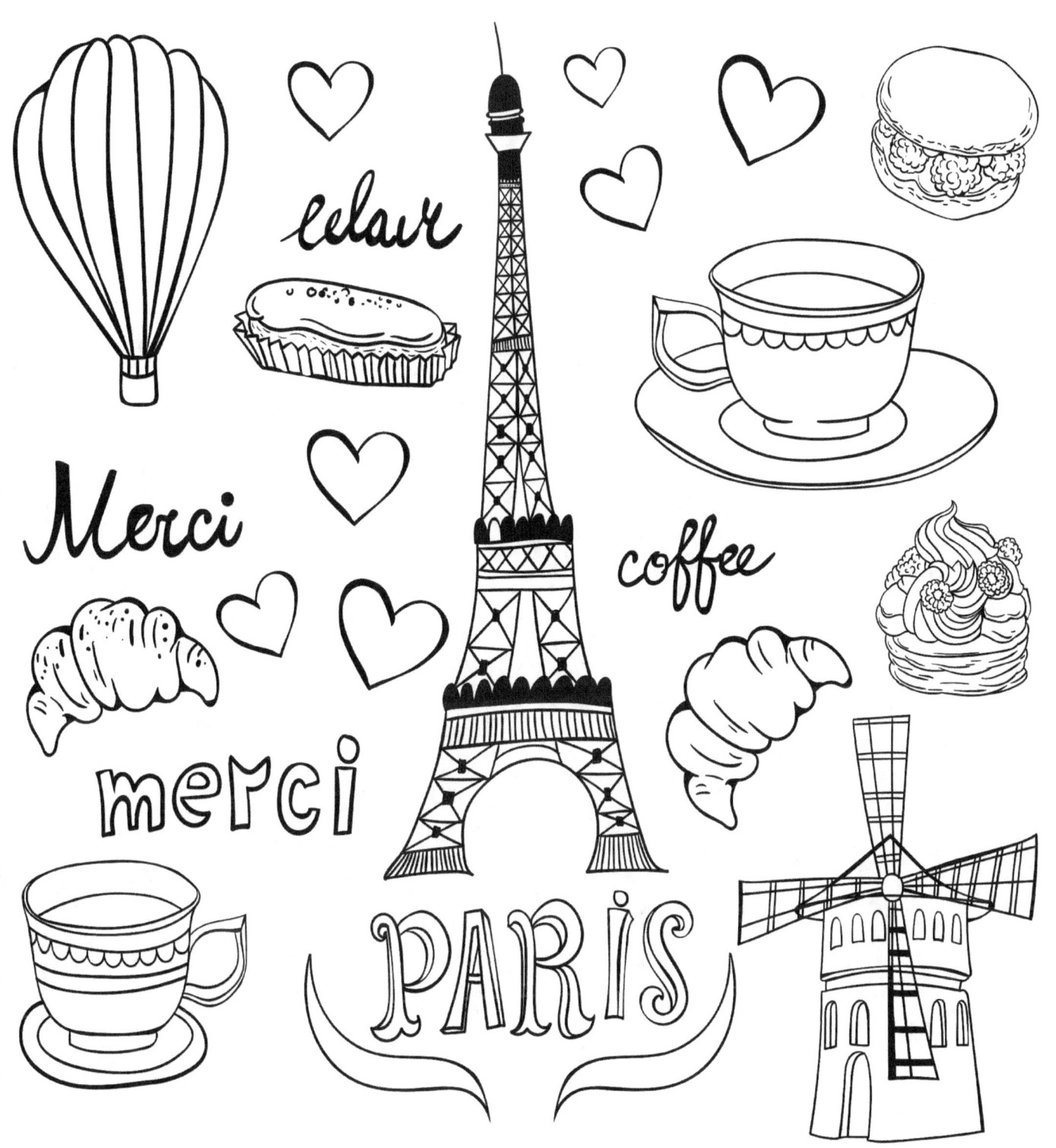